SEVEN SYRIANS

WAR ACCOUNTS FROM SYRIAN REFUGEES

Diego Cupolo

Interview Translators: Hazar Al-Mahayni and Hussein haj Ahmad

8th House Publishing

Montreal, Canada

Cover Design © 2013 8th House Publishing

Set in *Caslon* and *BostonTraffic*

A CIP catalogue record for this book is available from
LIBRARY AND ARCHIVES CANADA
CATALOGUING IN PUBLICATION
Seven Syrians (War Accounts from Syrian Refugees) / Cupolo, Diego (1983-)

ISBN 978-1-926716-26-8

8th House Publishing

Montreal, Canada

"In war, the first casualty is truth."

- Aeschylus

Special Thanks:

This book would not have been possible without Alice Bernard, Chadi Alhelou, Hazar Mahayni and Hussein haj Ahmad who offered their support to the Syrian people and helped preserve their stories.

Dedication:

This book is dedicated to all Syrians who have suffered as a result of war and the first boy that shook my hand at Al Salam School in Reyhanlı. He had lost his leg to a missile strike in Syria and asked me not to take his picture because he was ashamed of his handicap. Regardless of his crutches, he never stopped playing soccer.

SEVEN SYRIANS

Diego Cupolo

Introduction

A voice is missing from the international debate on the Syrian War. Throughout the conflict, world leaders have focused discussions on chemical weapons and radical fundamentalists while the Syrian people, civilians and refugees remain effectively absent from the conversation. Yet, as the war continues without foreseeable end, the simple truth is Syrians are dying and whether through bombs or sarin gas, the largest portion of the casualties are civilian.

In effort to give a voice to the Syrian people, this collection of seven personal accounts presents the war as experienced through Syrian refugees living in Reyhanlı, a Turkish town that was bombed in May 2013 for hosting a burgeoning refugee population. All interviews were conducted between July and August 2013 and have been adapted as monologues to create seven flowing narratives.

The Syrian conflict, like similar uprisings that took root during the 2011 Arab Spring, began as a civil war between an oppressed population and their ruling dictator, Bashar al-Assad. Since then, fighting has become locked in an apparent stalemate, causing more than 100,000 causalities over a two-year period with neither side gaining ground or significant advantage.

At the same time, the war has drawn involvement from neighboring countries, dividing the Middle East along Sunni-Shiite lines and morphing a national

conflict for democracy into a proxy war with implications that could reshape regional and international politics. To further complicate the matter, foreign militias associated with Kurdish groups and Al-Qaeda networks have also entered the conflict with intentions of forming new nations for their own ethnic groups and followers.

Caught in the battlefield is the Syrian population. More than 2 million civilians have taken refuge in neighboring countries while an additional 4 million have been internally displaced. These migrations have created the largest refugee crisis since 1994 and the numbers continue to rise.

From beginning to end, it is the Syrian civilian who bears the weight of this conflict. On one shoulder stands the United States with Saudi Arabia, Turkey and Qatar while the other holds Russia, Iran, China and Hezbollah. If and when these stacks fall and military intervention is undertaken in Syria, the question remains: Where will the Syrian civilian stand when the dust settles?

Story 1
Shelter in the Caves

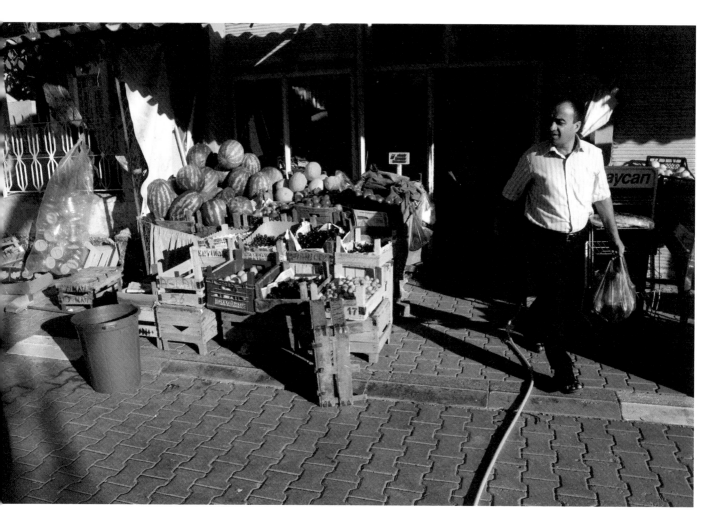

Hussein haj Ahmad - 33 years old, English teacher, Idlib region

I went to the caves after the military post near my village was attacked by farmers. They weren't part of a militia then, no organization whatsoever, but they were armed and they managed to kill more than a hundred government soldiers.

It was a surprise attack. Their first response after the military started shooting protesters in the streets. Some celebrated, but I didn't. I knew the air raids would come shortly after and they did. Bombs landed on my village every single day for the next two months. It was the worst experience of my life.

I took cover in the caves, up there in the mountains, and saw the bombs fall on what used to be my home. All I could do was watch. Each bomb was strong enough to destroy twenty to twenty five houses.

Worse, each bomb produced a very high, horrible screeching sound when it exploded. I don't know what they're called officially, but we call them pressure bombs. They were one of the many gifts Bashar received from Russia.

Usually, the air raids started at one or two in the morning when everyone was sleeping. Many people died this way, mostly children. A midnight rocket.

I stayed in the caves a total of 45 days, just waiting for the bombs to stop falling. I had no choice. During the initial protests, I broke my leg in three places. I could barely walk. I was on crutches this entire period. For food, for water I was completely dependent on other people. Fortunately, I was not alone.

There were many families in those caves, large groups of people I had never known before. As the time passed, we all became good friends, we all relied on each other.

It was a new experience for me because I was used to living alone. I would come home from work alone, watch TV alone and then go to sleep alone. There, in the caves, we did everything together. We took care of each other. Many had it worse than I did.

One older woman, she was blind. She was always terrified. She would hear the helicopters hovering above, but she couldn't see them and she had no idea if they could see her. Imagine.

In the day time, we would take her outside to get some fresh air, you know, to let her breathe. We all tried to get out for air whenever possible and every time we went out we took the old blind lady with us. We'd sit her down on a good rock so she could relax; but she never relaxed.

The minute she heard the sound of helicopters or an explosion in a distance she'd start yelling, "Take me to the cave! Please take me to the cave! I don't want to die!

Please! I don't want to die!" She'd swing her walking stick through the air as she yelled. "Take me to the cave!"

That's just one of the people I was with. There were many. Mostly women, children and the elderly. Men stayed in the village to fight Bashar's army. I was injured, so I couldn't fight, but even if I was healthy I would have stayed away. I don't want to die. I'm still waiting to marry. You know, this is very important for Syrian men. After university we are supposed to get married and start a family. I'm still waiting for this to happen.

It could've happened. There were some younger women in the cave. Sometimes they would talk to me. They told me not to worry so much, that I would find a wife after the war; but it's not easy. The war doesn't look like it will end anytime soon and I'm only sitting here, waiting, getting older. I still hope for a family of my own some day.

The fear I have is an abnormal kind of fear. I fear the rockets and the bombs more than others because there is so much I haven't accomplished in life. Up there in the mountains, in the caves without food, it's just suffering … just fearing … just thinking about the future … just crying sometimes.

There are questions, so many questions that you start asking yourself. Where can I go? What can I do? Will this war ever end? How long can I keep living like this? Should I keep living?

We all asked ourselves these questions in the caves. None of us knew whether we

would make it to the next day or not, whether we would endure the next battle. All Syrians are terrified about the future. We have no idea what will happen to us and this is an unsettling thought.

My house was hit by a rocket. I have no place to go back to. The Syrian Army bombed our village to punish us. They said we allowed those farmers to attack the military post so everyone must pay the price, even the children. There is no place for civilians in Syria, only armed rebels and Bashar's army. I had to leave.

As soon as my leg got better, I crossed the Turkish border to see what I could find in Reyhanlı. Many Syrians were going there so I thought maybe I could find a job or start a new life while I wait for the war to end. This has also been difficult. Local landlords take advantage of refugees. They see us like money. They charge us Istanbul prices to rent apartments in a little farming town.

Employers also take advantage of us. They pay us less than Turks. Much less. I was being offered 20 Turkish Lira for 15 hours of work before I got a teaching job at a private school.

I'm just barely self-sufficient now, but still, nothing is easy. You know there was a terrorist attack here? I was having a tea in the town center when the first bomb went off. It couldn't have been more than 25 meters away from where I was sitting. I ran as fast as I could. I went so fast I lost my sandals and ran barefoot over broken glass. My feet were a bloody mess. I still have some scars. See?

The locals blamed us for the attack. They said Syrians brought the war across the border. Angry mobs destroyed every car with Syrian license plates. We received threats. Our neighbors told us to move to another town. I didn't leave my house for 10 days. I didn't eat and lost two kilos during that time.

Now Reyhanlı is more or less back to normal. I work, I eat, I sleep, but I'm still looking for a way out of here. People say it's easy to reach Europe from Istanbul. First, I need to save up money. Then there's the paperwork. Always paperwork and I don't understand Turkish.

I just want to live without war again. I'm so tired of migrating. Of moving, changing apartments, being without friends. Being without family. I want to start a family. No one can understand our suffering.

—Hussein haj Ahmad - *33 years old, English teacher, Idlib region*

Story 2
On Discrimination

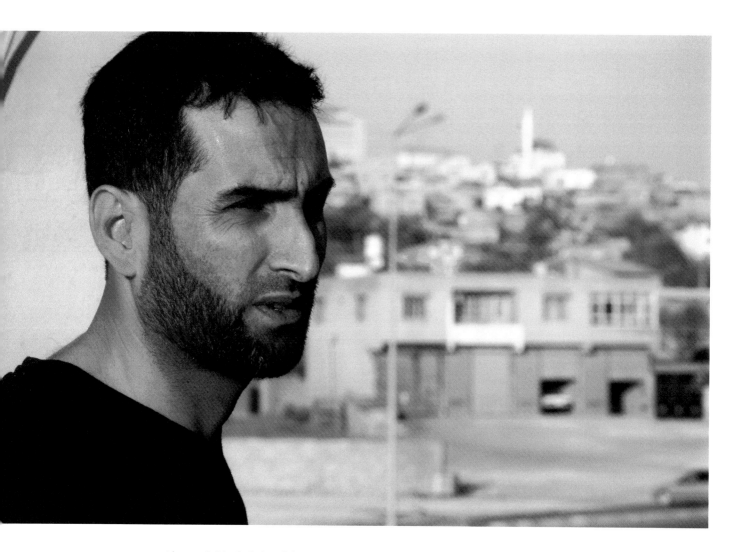

Ahmed Abdullah - 34 years old, Barber, Hama region

It is not because we have no money, no water or food that we suffer. Syrians can survive without these things. We have done it for thousands of years.

What hurts, what really causes us pain is the racism and discrimination we live under. The constant fear of a violent dictatorship. To understand our war you must first understand the background of our social conflicts. I am Sunni. The majority of Syrians are Sunnis, but we live as second-class citizens under an Alawite regime.

In Syria, it's not who you are or what you do; it's your religious background that determines which university you will attend, what job you get. It determines your entire life and the barriers are built as soon as you're born.

Let me give you an example. In my high school, Alawite students took their university placement exams with the help of teacher aides while Sunnis were left on their own in a different room.

What happens? We don't get the best scores and we aren't accepted into the best schools. Instead, most young Sunni men choose to do their mandatory military service after high school. That's what I did and, in return, I was degraded and humiliated by my commanding officers throughout my entire service.

In the military, they're mission was to make me feel worthless, stupid, incapable. They called it discipline. Then, when my time was up, they threw me back in the civilian world and I began looking for jobs without a degree, a specialization or any real work experience. I became a barber.

The case is very different for Alawites. After service, they can be promoted to permanent positions with the military. They get handpicked by senior commanders. This is exactly why the Syrian army does not protect Syrians. They are chosen specifically to serve the regime.

In the spring of 2011, we began demanding more equality and more justice for Sunnis in Syria. It was only a matter of time before the people rose up against such a dictatorship. I was there. I joined the demonstrations. They were peaceful at first, but then the military began killing young men for writing political graffiti in the streets.

A week later, my neighbors were forced to load dead bodies in a truck. When they finished, the soldiers shot them as well. Then the military began raiding the Sunni villages in my region. They burned all the houses and left nothing behind.

One time, I was in a neighboring village when the military arrived. They set all the houses on fire. I was hiding in a field outside the city, watching it happen when an army commander passed by in a truck and began yelling at the soldiers.

"Stop burning the houses," he told them. "I didn't come here to burn houses. I need people. Bring me people to kill."

They shot everyone they found. Mostly civilians. It didn't matter if they protested or not. Soldiers would enter each house and gather the families inside. Then they would threaten the parents, telling them things like: "We will burn your children in front of your eyes if you don't talk."

The parents would say whatever they knew, anything to save their children, but there was no hope. The soldiers would listen, take notes and then kill the families anyways. I heard a handicapped man was killed in my town this way. He couldn't even walk. They shot him with his daughter.

My town used to have 7,000 residents. Today, it barely exists. I brought my family to Turkey to get them out of the war, but I went back and forth across the border to deliver food and supplies. I worked for humanitarian aid. It was a good job, but it didn't last.

As the war intensified my organization stopped going deep into Syria. Instead, we

would drive to the border in the middle of the night and throw everything over the fence. Large bags of rice, bulgur, clothes, anything that could be useful. Many refugees left their homes with absolutely nothing. They don't even have blankets for the winters.

Still, what I have just told you is only one drop in a sea of horror. The people of the world have no idea how deep our suffering has been. I just want the killing to stop. The violence I have seen is beyond my capacity. What I don't understand is how the world can watch so many children die and do nothing. Why? Why doesn't anyone care about the Syrian people? Are we just unlucky?

One morning, I was walking outside my town when I found four men lying on a river bank, each one cut into pieces. Their body parts were in a pile near the water and their heads were stuck on swords that stood straight up in the mud.

I could not look away. I watched fresh blood drip down the blades. It was still bright red. A recent kill. What do you do when you see this? Try to think about it. What do you do when you see four men chopped up this way in your own country? What do you do?

Imagine you are walking in the street with your friend, talking about what you will eat for lunch, when a bullet grazes his neck and blood starts spraying everywhere. What do you do? My best friend died in my arms as I watched him bleed to death.

And the women! The children! They are not supposed to be involved in wars. This is against our most fundamental Islamic morals. Why are Bashar's men killing women and children every day?

I am a father. I have two kids. When you are a father and you see children dying in the streets, it does something to you, it is the worst thing you can ever witness in your life. Because of this, I cannot think of a better future for Syria. I have lost hope.

— Ahmed Abdullah - *34 years old, Barber, Hama region*

Story 3
Running for our Lives

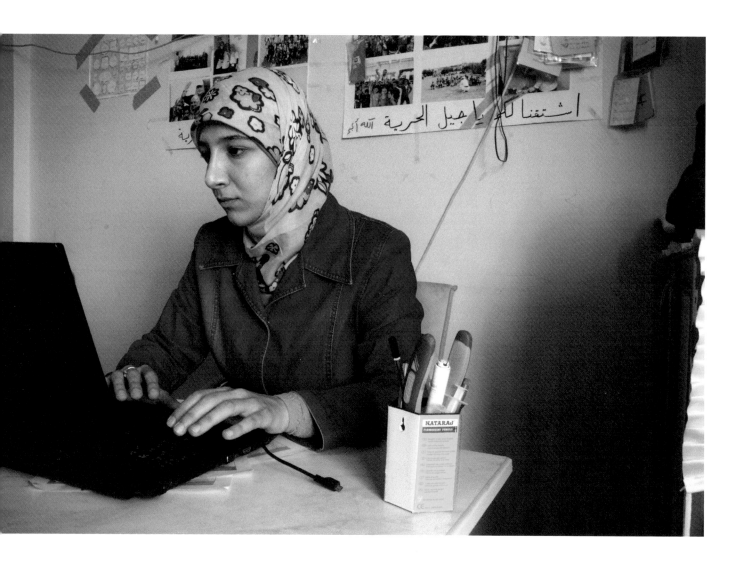

اشتقنالكم يا جيل الحرية الله أكبر

Aala Shaban - 23 years old, Student, Idlib region

In the beginning, I kept going to school. It was my last year of university. I was studying to become a teacher. Then, the army started shooting people.

They set up checkpoints around town where they would ask for your papers and check if your name was on their list. If it was, they would put you in jail and you'd disappear. I never took part in the demonstrations so I wasn't on the list, but my brother was.

One day he was going to school and a group of soldiers were standing at the front door. They were checking all the students as they came in. When he tried to enter the school they took his cell phone, all his money and then brought him to jail. My family was never told where he was or what happened to him.

For the next two months he was interrogated, tortured, kicked, beaten and humiliated. They tried to make him feel sorry for demonstrating against Bashar. He was moved around to different jails in Syria. Each time he arrived at a new place they would start the torture process over again. He wasn't allowed even one phone call.

My father worked hard to find him. I don't know how he did it, but eventually, we had to pay a large sum of money to get him back home. When he arrived, he was so badly beaten that it took him a month to walk again.

Unfortunately, this was the least of his problems. My brother wasn't allowed to leave the house because his name was still on the list. If they found him, he'd be sent back to jail. Worse, his involvement in the demonstrations put our entire family on the list. Soldiers knew where we lived and began surrounding our house at night. They would yell through the windows, threaten us. I can't describe the fear I felt.

We couldn't stay in our home anymore. We felt like the army would take us away in the middle of the night and that would be the end for us. That's when we moved into my uncle's house. But still, we were not safe.

A few days later, my father was stopped at a checkpoint and shot. The army took him to a hospital in Turkey where he stayed for three months as he recovered. During this same period, the army brought tanks into our town.

They began shooting houses, knocking down houses, burning houses that were filled with women and children. They did not care. Our village had revolted against the government and now the entire population had to be punished. Five people died in my cousin's family this way. One of them was a month-old baby.

We fled the after a tank destroyed our house with everything inside. We were left with nothing. For the next month, we moved around Syria, looking for safety, but where ever we went, the army would soon arrive with their list of names.

There was no escape. Without food, without water, we began walking through the mountains towards Turkey. Many people were doing the same so planes would fly overhead looking for us, dropping bombs on any movement they saw below. If we heard the planes coming, all we could do was hide under a tree and pray. This was how we reached Turkey.

When we crossed the border, we were running for our lives. I was scared, crying. I didn't know what we would find in Reyhanlı. I didn't know anyone. My family didn't have money. We didn't even have passports, but the Turks welcomed us. They were very nice to us and we were able to settle down here.

For six months, we lived without money. This was the hardest period of my life. We were just waiting, waiting, waiting to see what would happen in Syria. Everyday, we did nothing. Life was empty. I had no friends. No one in Reyhanlı speaks Arabic except for old people.

Then, after a while, my father finally got a job at a local hospital. Finally, our situation began to improve. I had been looking for work the entire time and I eventually started volunteering at Al Salam Center for Syrian Refugees shortly after it opened.

Soon enough, I began working full-time and I was happy to be productive, to be with Syrians again. Every time I walked through the school gates I felt better. It was the only place I could find peace.

After months of constant fear and depression, I felt like I was coming back to life again. Being around people from my country was like being with family. Today, almost a year later, I am still working at Al Salam. When the war comes to end, I want to finish my education degree and use my experience here to make a similar school in Syria.

Even though it's been hard and my city, my country has been destroyed, I know this war is worth it. The people of Syria deserve freedom of speech and freedom of expression. We need to get rid of Bashar's regime and make a new Syria, to create a better future where we have dignity, where we are treated like human beings. From this point on, there is no going back; Syrians can only move forward.

— Aala Shaban - *23 years old, Student, Idlib region*

Story 4
From Tadmor Prison to Reyhanlı

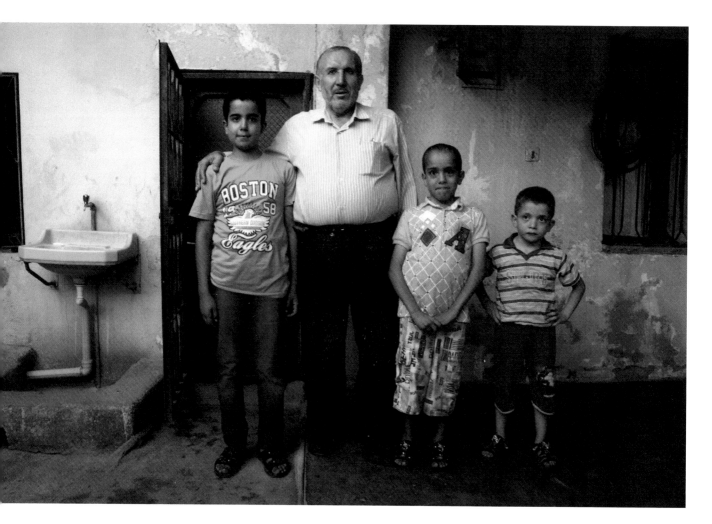

Abdul Abdurrazzak Othman - 65 years old, Retired, Idlib region

They kept us underground. Between one hundred to two hundred men in each prison cell. No windows.

We could barely breath. The air was so thick we made a rotation. Each man would get one minute to lay down by the entrance and breath the air that came in through the crack under the door.

One minute of oxygen. Hours of suffocation. This is how I lived for 15 years of my life.

They didn't put me in Tadmor prison because I was a protester, an activist or anything like that. I was apolitical. I was a scientist, a secondary school physics teacher. They put me in jail because I had a few friends in the Muslim Brotherhood. I wasn't involved with the organization in any way, but they said I could act as a partner, contaminate my students.

It was 1981 when they threw me in Tadmor. Only a few months earlier, the military was sent in to slaughter most of the prisoners. A massacre. It was the government's reaction to a failed assassination attempt on Hafez al-Assad, Bashar's father. Thousands of men died during a two week period.

When I arrived, the prison walls were still covered with their flesh. They had used grenades to blow up groups of men inside small rooms. The walls were black with rotten blood.

They continued the executions even after the slaughter. They had special execution days. Twice a week, guards would pick prisoners at random and either hang them or shoot them. In this way, 75 to 150 men were killed every week.

The first day I arrived at Tadmor, they blindfolded me and kicked me until I lost consciousness. From that point on, I received daily beatings with large wooden sticks. We all did. There was a process to it.

One military commander would watch while two or three guards beat me with the sticks. The commander was there to instruct them where to hit me. Usually he would focus the blows on one part of my body. Create as much pain as possible.

They always hit me on my left leg. I was beaten so many times in the same place that part of my skin, my thigh muscle, is still missing from my leg. Do you want to have a look?

The guards did terrible things to us. They never seemed to think, only follow orders. They would electrocute us with metal rods. They always targeted sensitive areas like the crotch and the armpits.

I often wonder how the guards slept at night. How they slept next to their wives when the day was over.

There were also shaving days. I hated the shaving days. They wouldn't let us grow our beards so every week hundreds of men were shaven with the same dull razor. The barber didn't care. He did his job as fast as possible and we bled horribly. They treated us worse than farm animals.

We were never allowed to rest. We were tortured all the time. We rarely got to go outside, above ground, and when we did, they would strip us of all our clothes and make us stand naked in front of all the men as they sprayed us with cold water. These were our showers.

How did I survive? I never stopped praying. Allah was always with me and protected me from all the torture my body sustained. The guards could damage me physically; and they did, but they couldn't hurt me beyond my flesh and bones.

In 1995, after nearly 15 years inside Tadmor, I was released on presidential amnesty. I was no longer a young man then. My health was gone and I was forced into retirement without pension.

Still, I tried to rebuild my life. I had eight children with my wife and watched them grow. Hafez died in 2001 and, at first, I was happy to see Bashar take over. One of the first things he did was close Tadmor prison. I thought our country was starting

to move in the right direction, but then the protests began.

Bashar reopened Tadmor in 2011 at the beginning of the civil war. They say a couple hundred anti-government protesters are in there right now. I would say there are more.

I did not participate in the protests, but when the air raids began I was forced to leave the country and move to Reyhanlı.

With me, I brought my three youngest sons. My two oldest stayed in Syria to fight. I haven't heard from them in over a year. I sit here now without knowing where there are, wondering if they are suffering the same torture I endured. I pray for Allah to save them as he saved me. Both my sons have children and wives waiting for them.

We are all waiting for them to come back. We are all waiting to live in a country where systematic violence are not part of the political strategy. We must overthrow not only Assad and his family, but the entire state intelligence machine that has terrorized our people for the last 40 years. No more secret police. No more Tadmor. We must build a civilized society.

— Abdul Abdurrazzak Othman - *65 years old, Retired, Idlib region*

Story 5
Number 9 out of 287

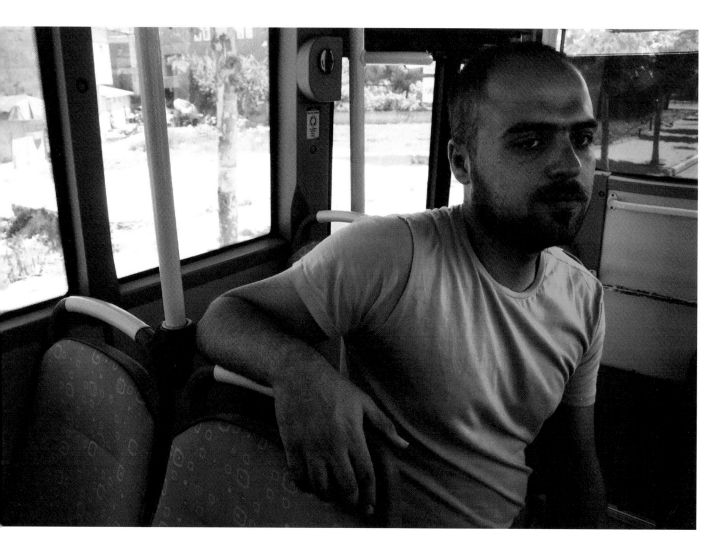

Muhammad Hallum - 23 years old, Student, Idlib region

I was number 9 out of 287.

The morning Bashar's forces occupied my town, I woke up to a call from my mother. She told me to hide, to get out of the house, get out of town if I could.

A few days earlier we had found my name on the military's black list. Someone had printed out copies and spread them around town. If your name was on the list, the military was looking for you and if they found you they'd arrest you, torture you and probably kill you.

This all happened because I took part in the first wave of protests that hit my village, the town of Saraqib. I wasn't violent in any way. I was protesting peacefully. Chanting songs, marching. Nothing more. I just wanted democracy, freedom and because of this I became a terrorist in the eyes the government.

When they came, I ran. What else could I do? First, I went to my uncle's house. He wouldn't let me in. He said the army would kill us both if they found me there. After that, I took refuge in an abandoned building.

I spent the entire day moving around town, alone, between buildings, hiding, jumping from roof to roof. Anything to avoid Bashar's men.

When you're running for your life, you know that failure means death and your body responds. You see a wall that's two and a half meters tall and normally you think 'No, I can't jump over that,' but when you are completely overwhelmed with terror, yes, you will find a way over that wall.

The biggest danger came from snipers on rooftops. They shot anyone that moved. Women, children, anyone. Their only job is to kill. You hear their shots. You listen for their voices, but you can't see them. If you do see them, it's usually too late.

I made it out by taking cover behind buildings. Always staying low. I was not in the town center and was able to avoid sniper fire while I jumped from roof to roof. Many were not so lucky.

The next week, I left Saraqib. I went to Reyhanlı, just across the border to find work and a place to live. My mother came with me at first, but she didn't like it so she went back to Syria. The army had left our town and she thought it was safe to return. This was the last time I saw her.

She was talking to a friend outside our house when a bomb hit. She died instantly. My nephew was also there, inside the house. Fortunately, he only got a broken leg. He's still recovering.... Can't walk.

I hate Bashar and I want him to perish along with all his men, but I cannot go back to Syria. I have made too many enemies.

Everyday, I post messages on the internet against Bashar and against rebel groups associated with Al-Qaeda, like the Al-Nursa Front and the Islamic State of Iraq and the Levant. If I go fight in Syria I will have to watch both my front and my back. I have received threats for my posts against these extremist groups. They tell me, "Be careful. Don't speak. We can get you where ever you are."

All this because I support peace. It's terrible. First, my region was occupied by the Syrian army, then when they left, the Al-Qaeda groups took over. They say they are Muslims, but I don't think so. Islam, in its roots, is peace.

These are terrorist groups that kill anyone who opposes them. Non-believers, catholics, Jews. I don't think they have any humanity. They justify their violence by using the Quran and twisting its words to serve their purposes. Our religion is simple: Muslims are not allowed to kill, but Al-Nursa would tell you otherwise.

What's strange is many people in the West seem to think these Al-Qaeda groups are a powerful force in Islamic countries. The reality is they make up between one and two percent of all Muslims. Their influence on political discussions is ridiculous.

People also don't seem to understand that nearly all these rebel groups aligned with Al-Qaeda are not from Syria. They are foreigners. I would say about 95 percent come from Afghanistan, Iraq, Libya and other countries in the Balkans and Europe.

It's a terrible situation for the Syrian people because we don't want a country ruled by Islamic

fundamentalists. Without more support for the Free Syrian Army, it looks like that's where we are heading. Groups aligned with Al-Qaeda have a lot more allies than the FSA. They have money, weapons, everything they need; and nobody knows where it comes from. Maybe Iran, I can't say.

I think these groups are taking advantage of our fight against Bashar. They see the war as an opportunity to claim territory. To make a base in the Middle East. It's the same with the more radical Kurds. Syrians don't want to see a West Kurdistan either. We just want a Syria without Bashar, without dictatorship.

Sometimes I think about going back to Syria and fighting. Fighting for democracy, not for religion. I can't leave my country in the hands of foreigners. There is a rifle waiting for me if I go. I'm trying to decide now.

The war is becoming more complicated with every month that passes. Without intervention, the violence could go on for five, six, maybe ten years. My country might split up into four new nations.

All I know is Syria will be full of weapons when the war comes to an end. Everyone will have their own Kalashnikov and make their own mafia. What a great future awaits us.... Groups of people sitting around with Kalashnikovs. Great.

— Muhammad Hallum - *23 years old, Student, Idlib region*

Story 6

The Letter B

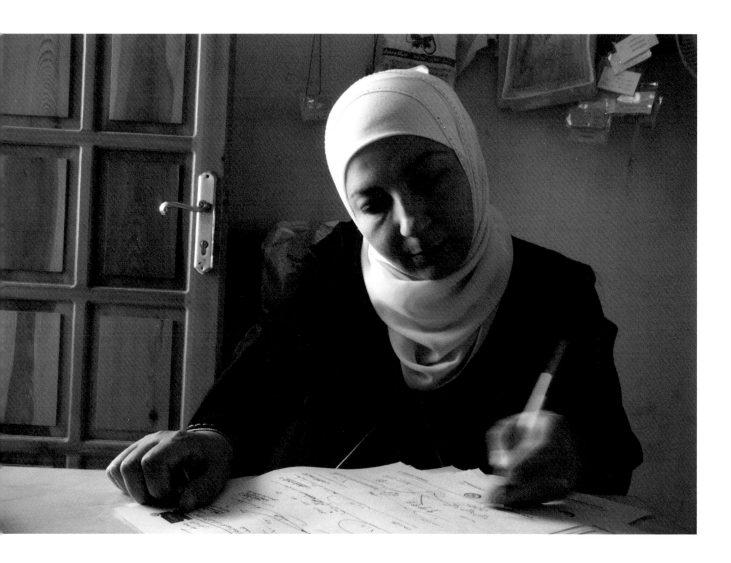

Abir Hashem - 36 years old, Primary School Teacher, Allepo region

When my students write the letter "B," they cross it out. Some stopped writing all together. For them, "B" stands for Bashar.

One day, I was teaching the alphabet and one of the boys said he hated this letter. Started yelling. He was so angry. Just six years old.

The influence of war has been too heavy on the smaller children. They are young and they relate everything to violence. When I draw pencils on the board, they see missiles. When I draw a cloud with rain drops, they see a plane dropping bombs.

It's hard to talk about families because many children have been separated from their relatives. They lost their parents and live with their uncles, grandmothers, cousins. There is no stability in their lives so they always talk about their memories of Syria, wanting to go back to Syria. They talk about life before the war.

Yesterday, there was a lesson on "home" and "what is my home." I gave them papers to draw their homes and some drew houses that were on fire, houses that were destroyed. One drew a tank next to his house.

I see it in my children as well. I am a mother of three girls and one boy. My youngest daughter also talks about our old house all the time. She always says it was so big and so nice.

"What happened to our house?" she asks me. "What do you think happened to all my toys? Will they still be there when we go back?"

I just tell her not to worry. That she'll get all her toys back after the war. What else can I say?

I am like any human being. Maybe I look strong when I stand in front of the classroom, but most of the time I am trying not to cry. The children tell me so many stories. How their fathers died, how they lost their friends, everything. They are so small.

I often go home depressed. Every day there is a new story about someone's brother who did not come home. We all have relatives that are still in Syria and we always receive bad news.

At the beginning of the revolution, I was always out in the streets to protest. I was

also a teacher then, but got fired when the school administrator found out I was part of the movement.

It didn't matter. I was doing whatever I could to support the demonstrators. When the military started shooting people, I drove my car around with medical supplies to take care of the wounded. This was illegal, of course, and the police put my name on a list because of my actions.

They began searching for me in the streets and in my home. I had to move. I stopped going out during the day. I changed my clothes and covered my face, but I was still active. All the women in my neighborhood were scared. They told me to stop supporting the protestors. "It's too dangerous for a woman," they would say.

The men also. They would tell me to stay in my home, but I could not. This was too important. We needed to do whatever we could to get rid of Bashar and his regime. Egypt and Tunisia had done it and we really believed we could do the same in Syria.

With my car, I would also deliver food to the protesters. Keep them energized because we slept very little in those days. One night I bought ten kilos of meat and began driving to a house where revolutionary leaders held meetings.

I didn't know it, but the butcher was suspicious. "Why are you buying so much meat?" he asked me. I didn't answer. Then, when I left, he reported me to the police.

Ten minutes later, I was stopped by the military and they began interrogating me.

I didn't know what to do so I forced myself to cry like I was confused or scared. Fortunately, they let me go that time, but it got worse after that.

I became known as a revolutionary in my town. There weren't many women in the movement and I stood out. Eventually, the military came looking for me in my apartment complex. I was home with my husband and children at the time. We watched them go from door to door, checking each apartment. There were men with rifles asking my neighbors where I was.

I was trapped. I couldn't go out of the house. The military had surrounded our apartment and I didn't know what to do. The soldiers knocked on every door, asked questions, repeated my name. Then I heard their footsteps coming up the stairs, approaching our door. In that moment I asked my husband to divorce me.

I figured one of us should stay alive to care for our children. Maybe if he divorced me and told the soldiers I was acting alone, that I was crazy, maybe the military would only take me away and leave him with our kids. I was crying. I was begging him for a divorce. I wanted him to blame me for everything.

Then, somehow, I don't know what happened, but the soldiers skipped our door. I think they arrested one of my neighbors and took them away. I'm not sure, but they never knocked. Maybe it was a mistake, I can't say. They stayed in our building for a while longer and then left. I couldn't believe it. We had been spared.

I left Syria after that night. That was enough. I moved my family to Reyhanlı. We

came without food, without clothes, without anything.

At first, we weren't doing much, just waiting. In this period I began gathering the neighborhood children, all Syrian refugees, and I started giving informal classes in my backyard. I wanted to make the best of my time.

Then I was lucky enough to get a job at Al Salam School for Syrian Refugees. I have stayed there ever since. It's stable and I like to teach children. That's what I do.

Every week, the school receives more children that only recently left Syria. Many of them have been out of school for more than two years. It's a hard job, but I just try to keep them from thinking about the war. I focus there attention on the future.

They just need a safe place where they can play and be children again. They are so young.

— Abir Hashem - *36 years old, Primary School Teacher, Allepo region*

Story 7
Talking About Democracy

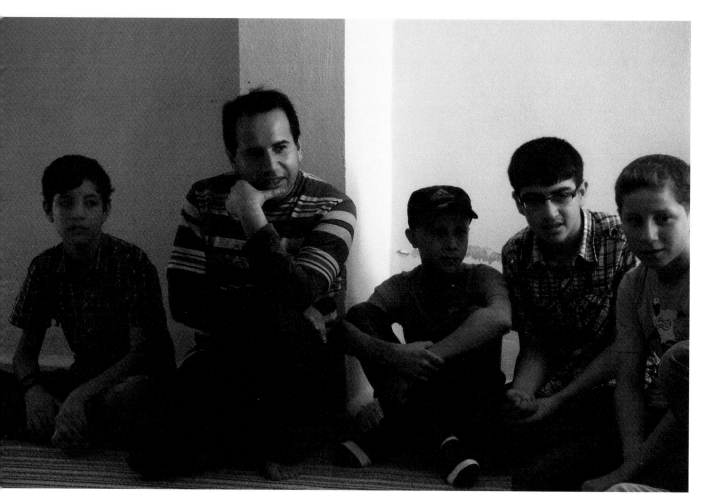

Abdulghaffar Abdulla Othman - 35 years old, Math Teacher, Damascus

I was in the Syrian Army when the revolution started. One year mandatory service. No, I wasn't with the ground forces though. I was working in the military accounting office in Damascus.

But that doesn't mean I was safe. I watched protesters get beaten violently during demonstrations. Soldiers tortured them in front of us, right there in the street to make an example, to show their actions were not acceptable. I didn't agree, but I had no choice. I had to keep doing my job.

Then it got worse. One day I was with my wife in the city center when snipers started shooting down at civilians. It seemed like they were killing random people. My wife was pregnant at the time.

We panicked and took shelter in a mosque. Mosques are supposed to be off limits; the military can't touch them, but the soldiers surrounded the building anyways and threatened us with their rifles. There were many people inside. Everyone was yelling. It could've turned into a riot at any moment.

I was afraid for my wife so we left the mosque. I used my military ID to pass through the line of soldiers and then, when we were only a few blocks away, an air raid began and a bomb hit the mosque. I watched the entire roof collapse. There were so many people inside.

Everyone began running in every direction. Smoke made it hard to see where we were going. Tanks rolled through the streets. We took shelter in a school and waited.

After that day, it became clear that we had to leave Damascus. It was too dangerous. We went to some relatives in Idlib only to find out my sister's husband had just been killed. The soldiers arrested him for protesting and he died in jail, most likely while being tortured.

I was still with the military at this point, but only because I would be found guilty of treason if I left my post. They hang soldiers that abandon the Syrian army. Then a rocket hit our family home in Idlib.

No one was hurt, but it happened just three days after my wife gave birth. It was a girl. I was now a father and I had to take responsibility for my family. I had to get them to a safe place. That's when I finally decided to leave the army and to leave Syria.

With that decision, I became a fugitive, a deserter. Because of this, I set out for Turkey on my own. I left my wife with the baby and told her to wait until I found my way to Reyhanlı. I travelled through the mountain roads. I moved only at night.

If they stopped me at a checkpoint, I am sure they would have killed me.

My wife suffered a great deal while she waited. I could have died at any moment and she wouldn't have known. These thoughts terrified her so much that she lost the ability to breastfeed our child. Her body stopped producing milk.

The road to Reyhanlı took more than a month to complete. I had to go very slowly, always with caution, but I made it to Turkey. Soon after my wife came with the baby and we were reunited in a safer place. Then my father, uncles and other relatives came to find us.

Some didn't make it though. Five members of my family died from sniper fire. They weren't even protesting. My cousin was shot while he was painting a house in the middle of the day. He was standing on scaffolding and fell after the bullet hit him. He was just working.

His father was also shot to death on the same day. He was sitting in his house, watching television when a bullet came through the window. The Syrian Army kills for fun. Violence is just a game for them. We were very fortunate to get out when we did.

When I first arrived in Reyhanlı I worked in a restaurant. Fourteen-hours a day. Very low pay. After a few months I was able to get teaching jobs at different schools that had been opened for Syrian refugees in the area.

Though I am trained as a math professor, I use my time with the students to teach them about democracy. If we are going to see progress in Syria, we will need to build a new generation based on democracy. We want our basic human rights. We cannot return to Syria as it was before, that country does not exist anymore. Our towns have become nothing more than ruins and mass graves.

It is clear this war will take a long time to end. While we are here, waiting outside our country, I think we must start building the foundations of a new Syria. I am teaching my students to vote, what it means to have elections, what it means to have a choice.

We never had this in Syria. We were never taught about democracy in our schools. The idea of choice is something foreign to us and this is not right because most Syrians are well-educated. We are moderate, peaceful people. We deserve better.

I hope it works. Maybe one day we can have real elections and Syrians will choose their leaders. I really hope so. I just found out my wife is pregnant with our second child. We don't know what the future holds, but we simply want our children to grow in a better Syria than the one we left. I look forward to returning someday.

—Abdulghaffar Abdulla Othman - *35 years old, Math Teacher, Damascus*

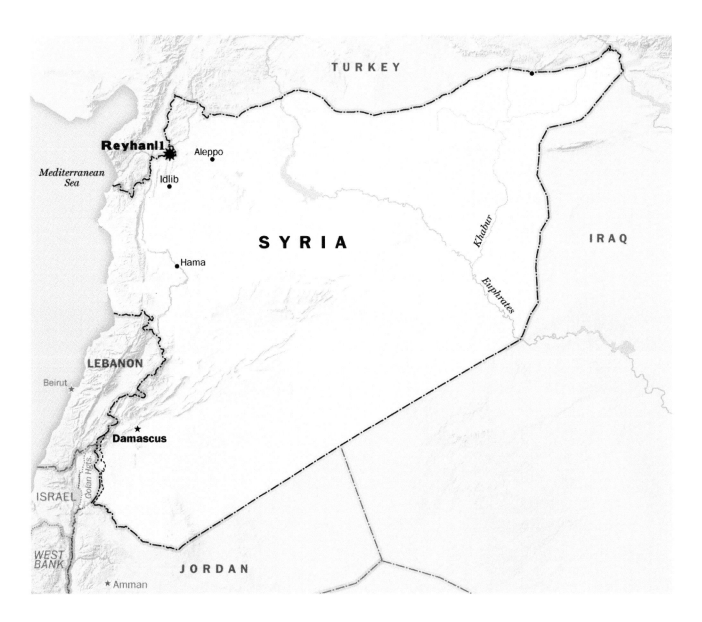

Field Notes

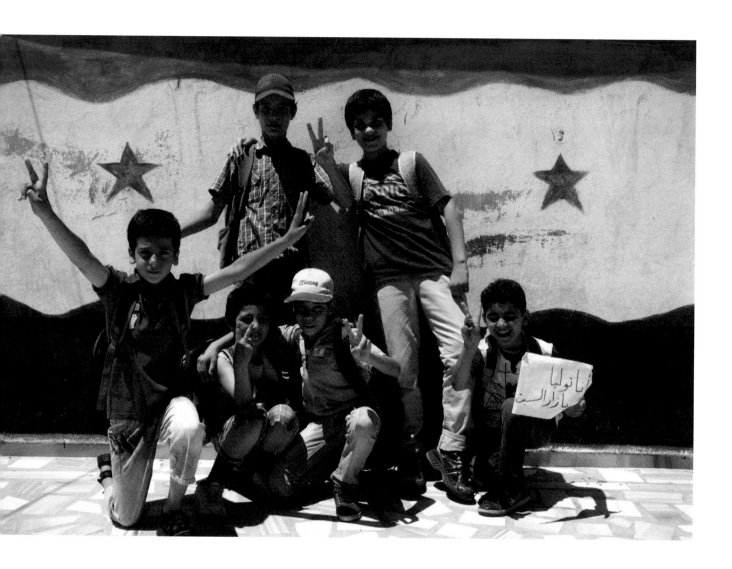

The materials in this book were gathered while the author, Diego Cupolo, and his partner Alice Bernard volunteered as teachers at Al Salam Syrian Learning Center in Reyhanlı, Turkey during the summer of 2013.

The following section includes notes and photos on life in this small border town, which before the Syrian war, was long forgotten as a distant farming community with mixed ethnic groups. It was not until 2011, when the first waves of refugees began settling in Reyhanlı, that locals were exposed to large numbers of foreign visitors, let alone international aid workers.

World Refugee Center

From the beginning of the civil war until September 2013, the United Nations Refugee Agency registered more than 2 million Syrian refugees living abroad, with the majority staying in Lebanon, Jordan, Turkey and Iraq.

An average of 10,000 people crossed the Syrian border each day in the spring of 2013 and the numbers continued to rise throughout the year. By the end of the war, the UN estimates more than 10 million Syrians will need humanitarian assistance, meaning half the total population of Syria. The conflict has caused the largest refugee crisis since the Rwandan Civil War in 1994.

In Reyhanlı, a town less than one mile from the Syrian border, a countless number of refugees arrive each month using various mountain crossings. The large influx of people into the small farming community created tensions between new arrivals and locals that resulted in a terrorist attack in May 2013. Two car bombs exploded in the town center killing more than 50 people and injuring 140.

At the time of publication, the perpetrators of the act remain unknown and investigations are ongoing.

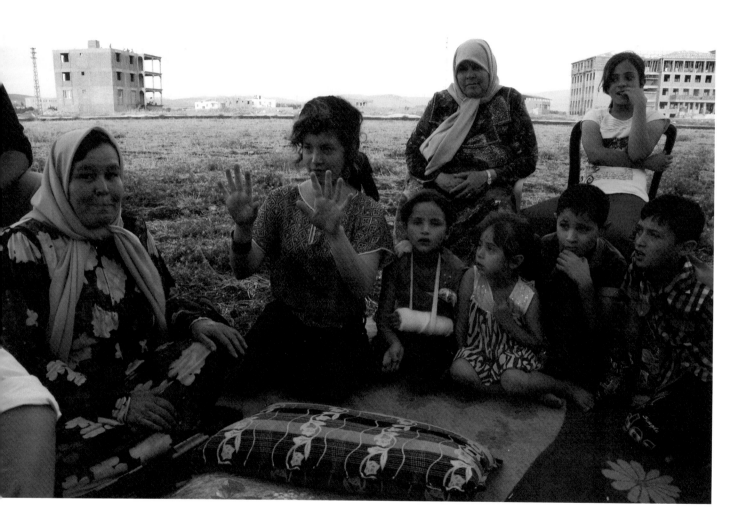

After Tea

They didn't have much, but they invited Alice and I for tea on a rug outside their home. They were new arrivals in Reyhanlı. We shared stories, boiled water and reboiled water before one of the men stood up and told us he was leaving.

"Where are you going?"

"To Syria," he said. "I'm going to the front line."

An older women looked at us and explained.

"Every few days he goes to fight the war in Syria. When he finishes his shift, he comes back to his family in Reyhanlı and rests. All the men do it," she said.

He put down his tea cup, shook my hand, mounted his motorcycle and drove off.

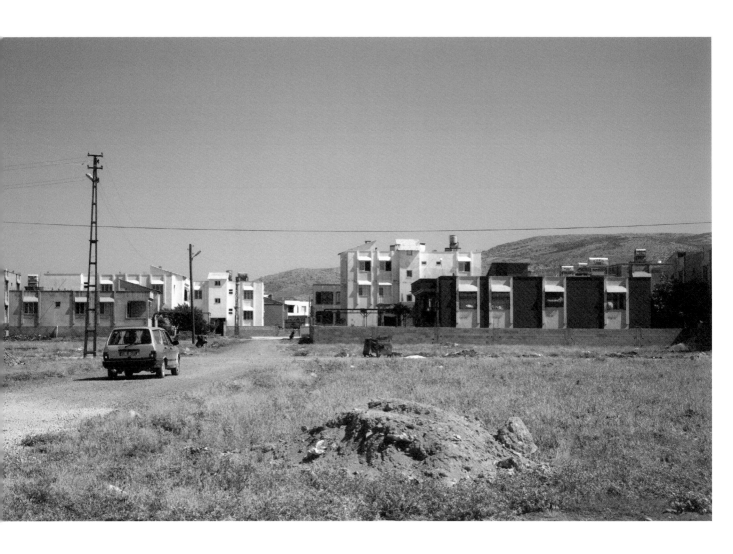

Reyhanlı with a camera
Notice the white reverse lights.

Our second day in Reyhanlı, Alice and I went out to buy food. I took out my camera just as a station wagon passed on the road. Immediately, the driver hit the brakes and backed up. He jumped out of the car, yelled something in Turkish and showed his ID. It read "POLIS" in thick red letters.

He repeated, "No photo! No photo!" while pointing at the mountains, the ridge forming the Syrian-Turkish border. With his hands, he mimed binoculars over his face. "No photo! No photo!" pointing at the mountains.

Alice and I explained we were volunteer teachers at a Syrian refugee school. Once he understood our broken Turkish, he nodded, got in his car and drove off.

What binoculars?

Later, coming back from the food market, three men passed us on motorcycle. One of them was holding a long black sniper rifle with a scope. The three waved their hands, smiled, and disappeared around the corner.

Those binoculars.

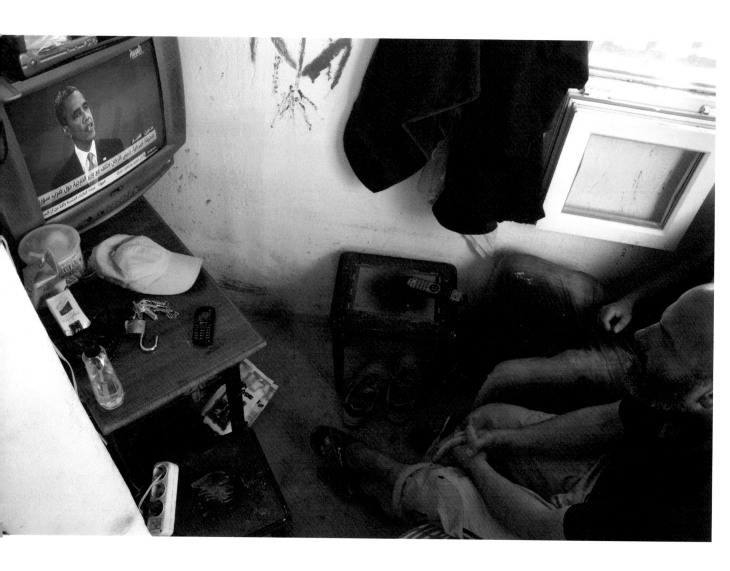

News Hour in Reyhanlı

The 2013 G8 summit came on the news as we watched TV with Syrian refugees in Reyhanlı. One of the men laughed and said, "Look at all those world leaders talking about everything they won't do in Syria. Thank you very much."

Then images of the protesters in Turkey and Brazil flashed on the screen. Alice and I said the police in Istanbul had been violent. The same Syrian responded:

"We wish our government was throwing tear gas at us. They're shooting our people in Syria. Tear gas would be nice. Tear gas would be like having a party."

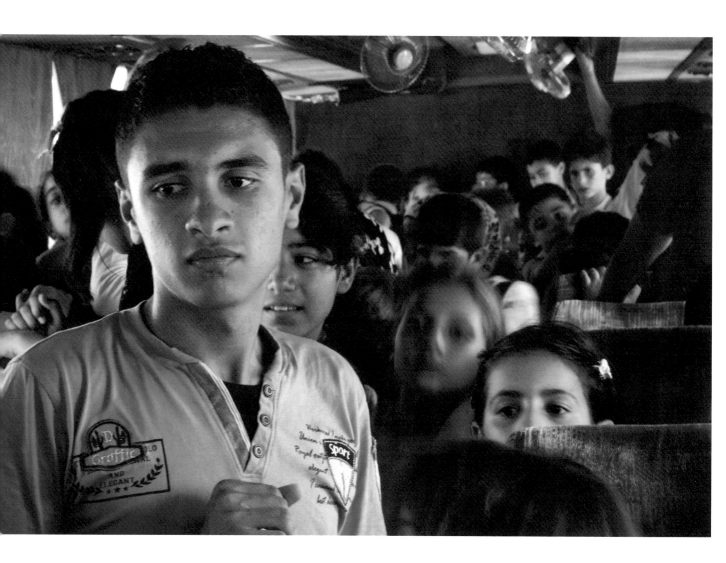

Ahmad Alshik

"Not long ago, we enrolled a child whose father died while fighting in the war. It was a difficult case. He kept mentioning his father, how he wanted to be with his father. When he came to school he didn't play with the other children. He sat alone, didn't make friends. He only talked about his father. Now we don't see him anymore. He only came a month or two and then left. I still think about him."

- Ahmad Alshik, *Teacher's Assistant at Al Salam School*

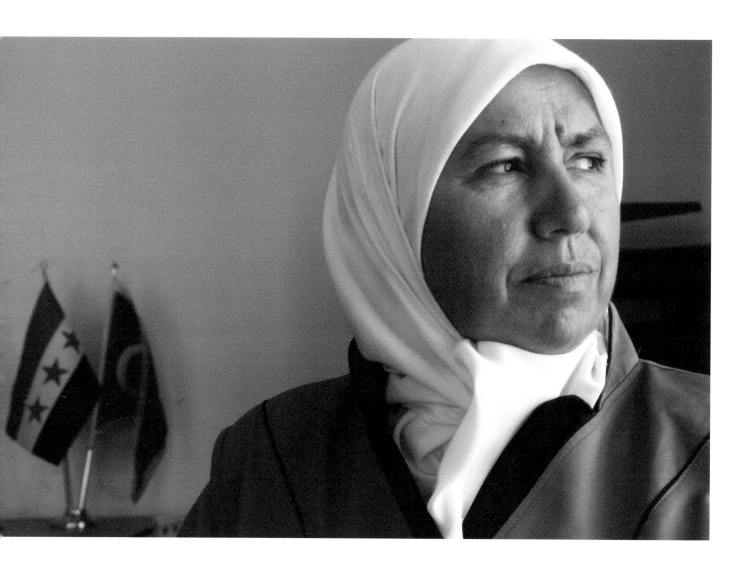

Lamia Nahas

"If these stories were happening in another country, people would talk about them for years. Here, we simply get used to them. They have become a normal part of our lives. Everyone has their story."

– Lamia Nahas, *co-director of Al Salam School*

Photographs

Contents

Photo Credit: Aldo Adinolfi

Author Bio

Diego Cupolo began his journalism and photography careers in New York City and has continued his work while residing in Montreal, Quebec and Buenos Aires, Argentina.

Today, he serves as Latin America regional editor for Global South Development Magazine and works on the road as an independent journalist, having reported on Syria, Turkey, Bulgaria, Nicaragua, Peru and Chile. His written and visual work has appeared in The New Yorker, The Atlantic, The Associated Press, The Village Voice, The Australian Times, Discover Magazine, The Argentina Independent and Diagonal Periódico.

For more information, visit http://diegocupolo.com

CPSIA information can be obtained
at www.ICGtesting.com
Printed in the USA
LVIC04n0018191215
467211LV00012B/44